As I was searching for a new way to relax after a stressful day, I happened upon the phenomenon that is Adult Coloring.

At first I thought I had found a new oasis of tranquility to help decompress from my high-strung tension filled "normal" day. But after a short while I quickly grew tired of the same old floral, paisley, and mandala patterns.

I won't mention my lone foray into the world of Adult Swear Word coloring. (this is supposed to be relaxing?)

Every book seemed to look the same, and I began to experience Deja-vu. Identical flowers, patterns, and pictures of birds, fish, and cats filled my evening relaxation session with a sense of the mundane.

Relaxation is what I was seeking, not boredom.

I understand that not everybody is a creative visionary, nor do I claim to be one. But, I personally like a little bit of inspiration and uniqueness in my adult coloring books.

Ok, so as you look through Alien Design coloring books you might see some familiarity, but with enough of a twist to keep things interesting. No, not every design is unique, we do need to stay grounded in reality after all. But I think you'll find enough unexpected divergence from "normalcy" to capture your imagination and help make the stress and tension melt away like butter on warm toast.

Some tips for Alien Design.

1. Every design is printed on a separate page. Place an extra sheet of paper or cardboard (or even rip off the cover of the book) underneath the page you are coloring to keep the colors from bleeding.
2. Begin anywhere you want. We are Aliens and Earthling rules DO NOT APPLY.
3. Use any medium you choose. We used heavier paper than normal coloring books. Pencil, ink, even paints should be ok.
4. Use any damn coloring scheme you like. Again, we are Alien Design. (see tip 2) Want a yellow sky, fine; like pink trees, ok; how 'bout some purple water…(well, in that case your just a weirdo…My kind of people…) ;D
5. Experiment with shading and placing a point of light in your art. This creates more depth and makes the coloring page more interesting and professional looking.
6. Have fun, relax, and just let it all go.
7. Be sure to check our Amazon page for upcoming releases.

IF YOU PURCHASED THIS BOOK FEEL FREE TO SCAN AND PRINT OUT THE DESIGNS AS MUCH AS YOU LIKE.

IF YOU *DIDN'T* BUY THIS BOOK, WELL, SHAME ON YOU…

NOW GO STRAIGHT TO AMAZON.COM AND BUY A COPY.

ALL IMAGES AND TEXT COPYRIGHT ALIEN DESIGN© 2016

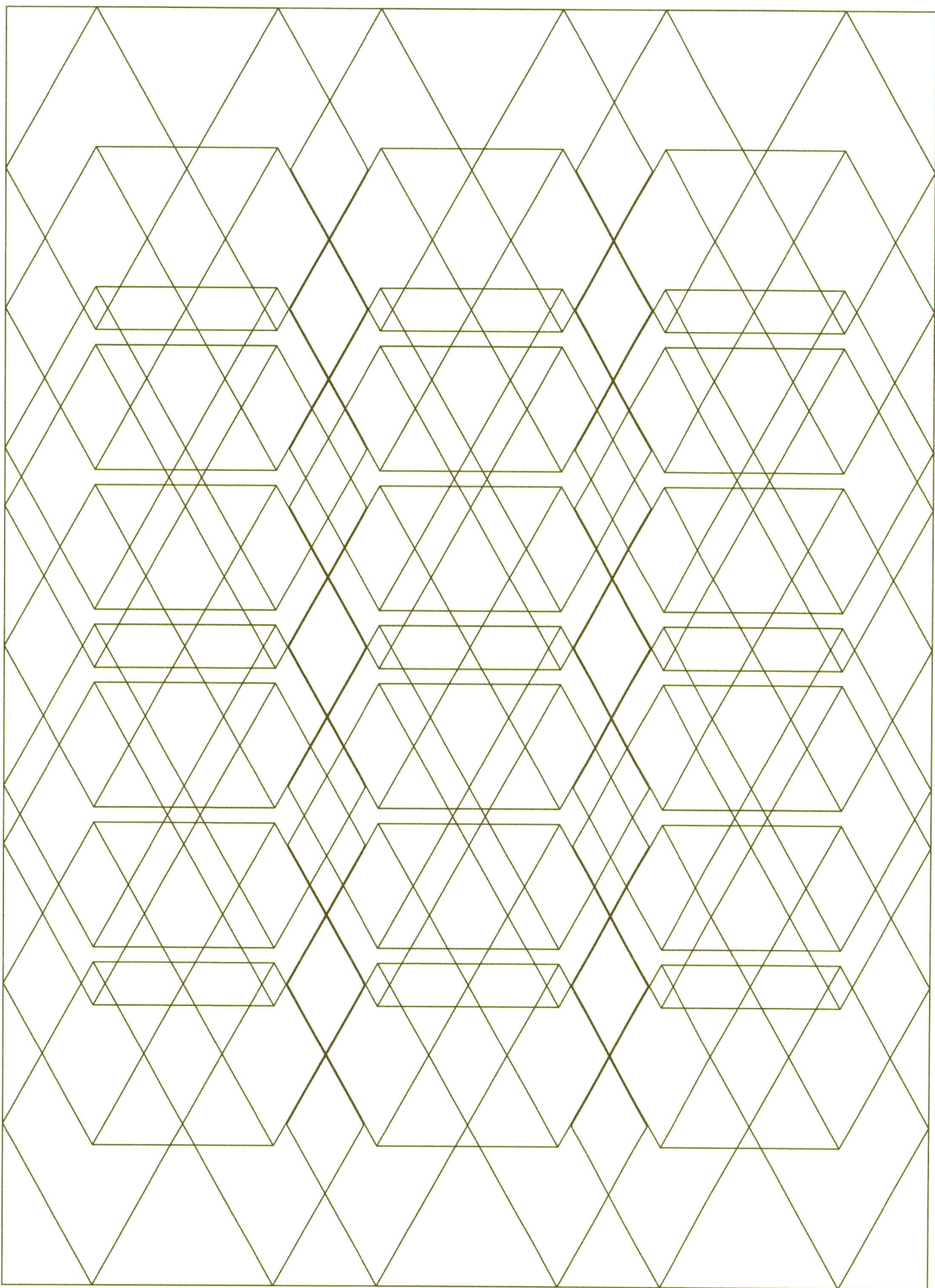

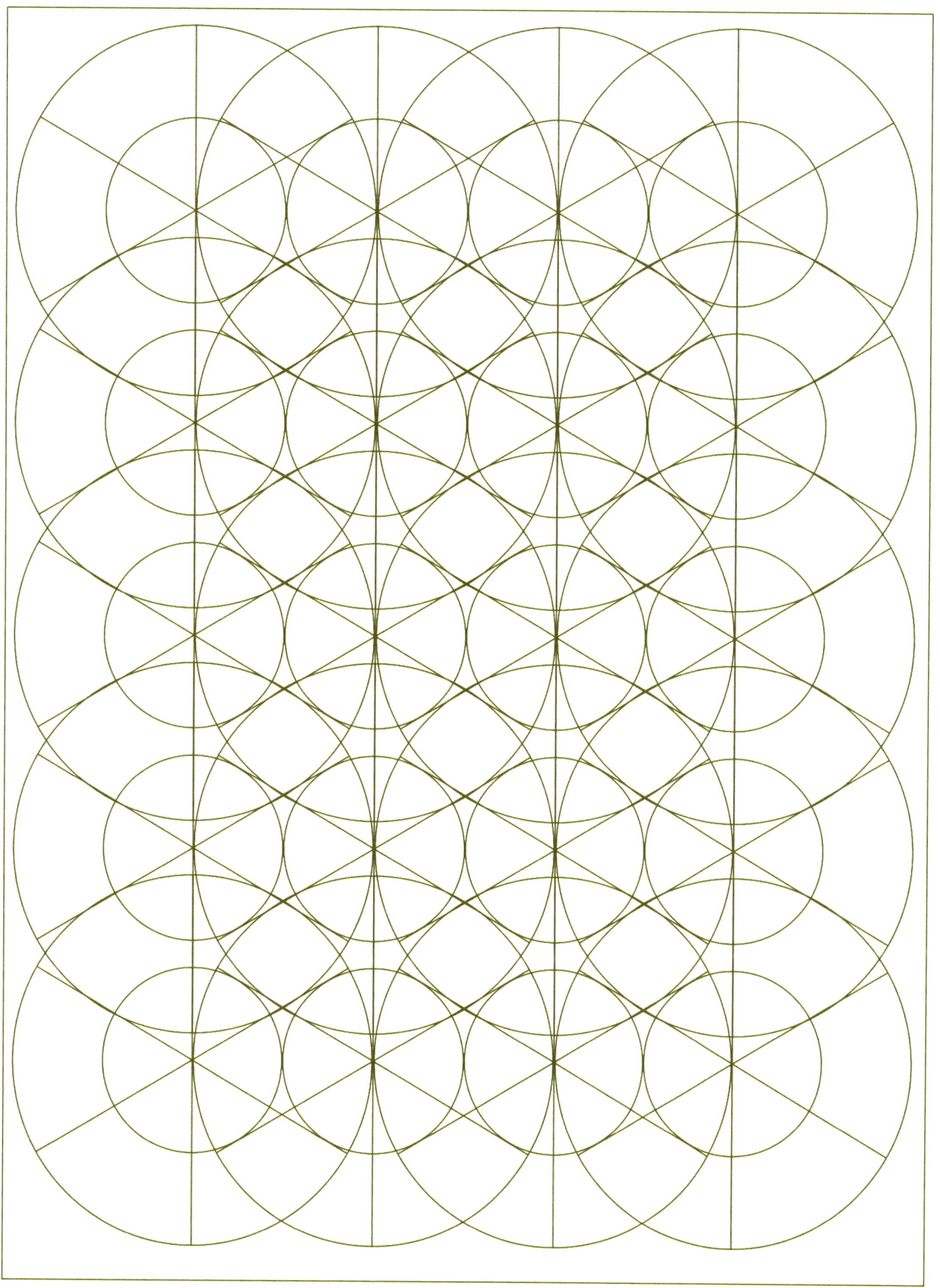

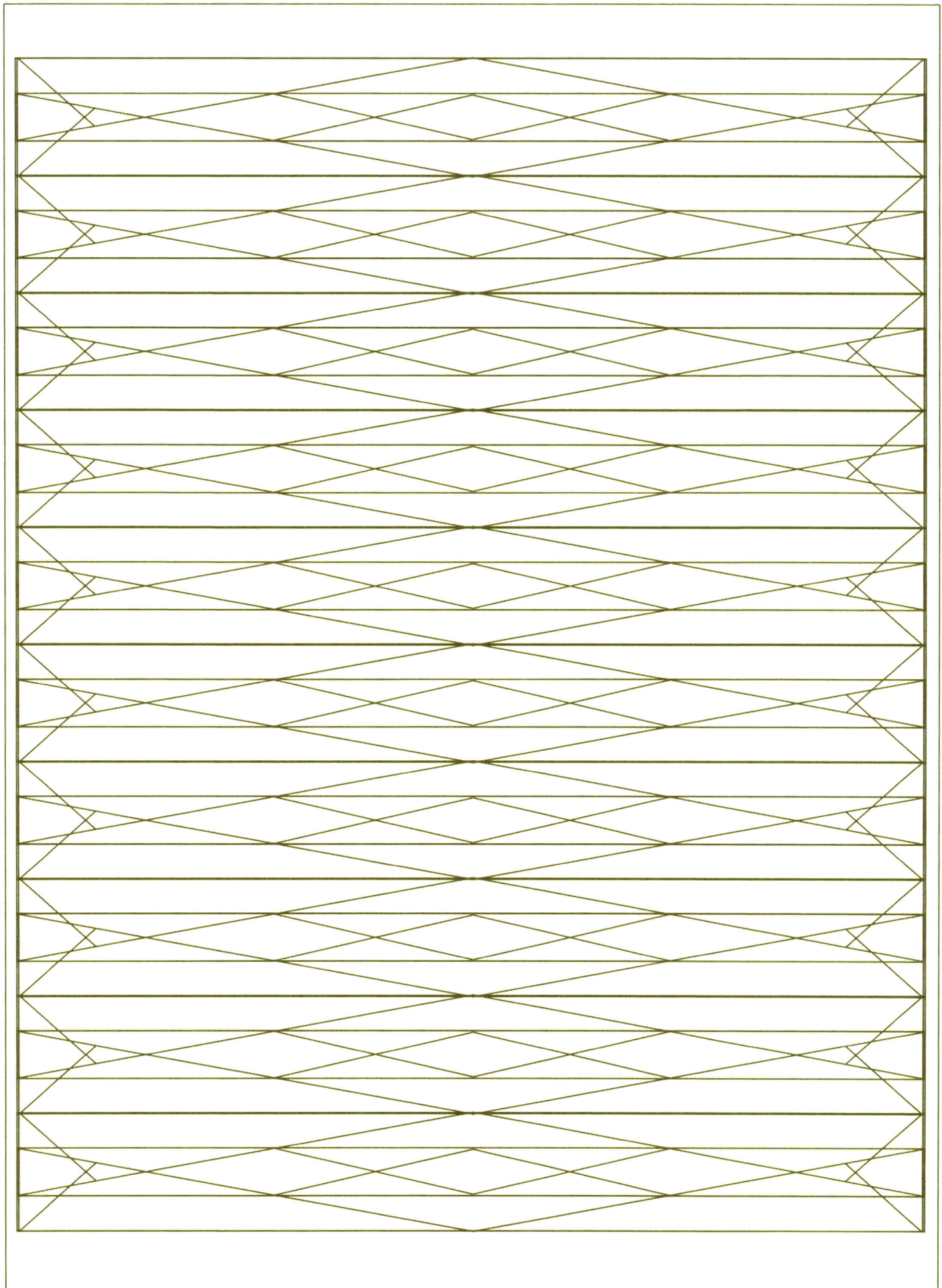

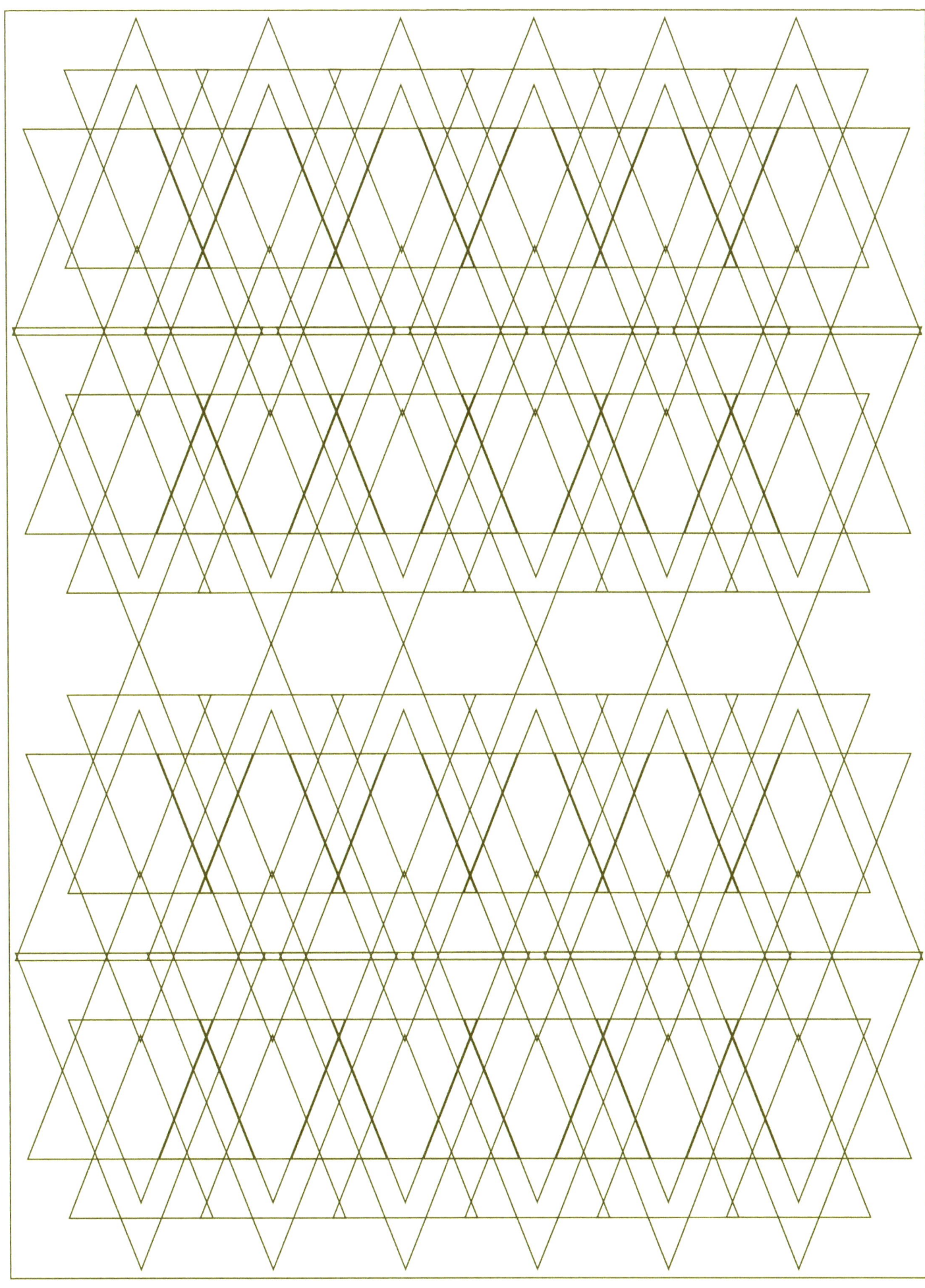

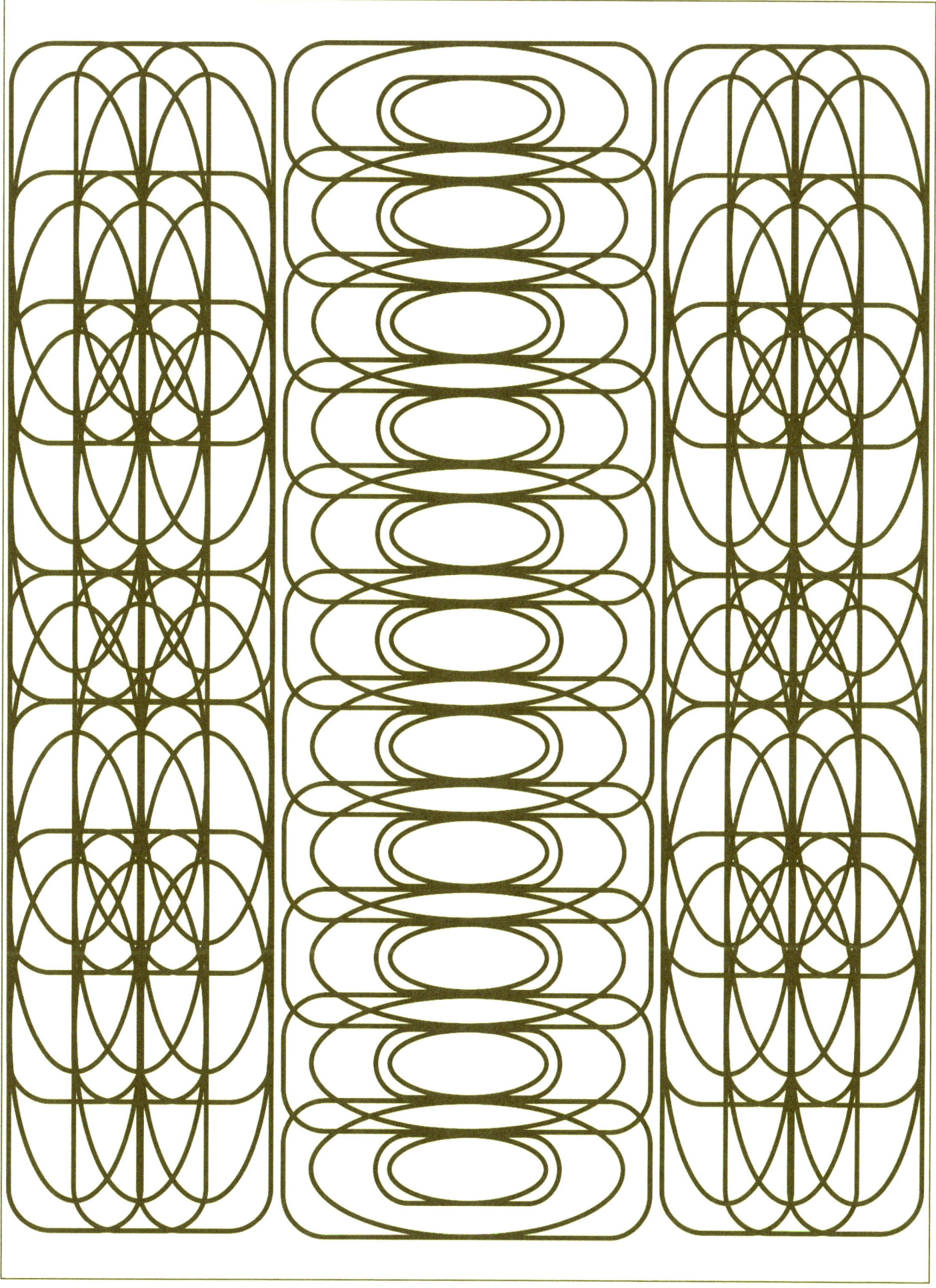

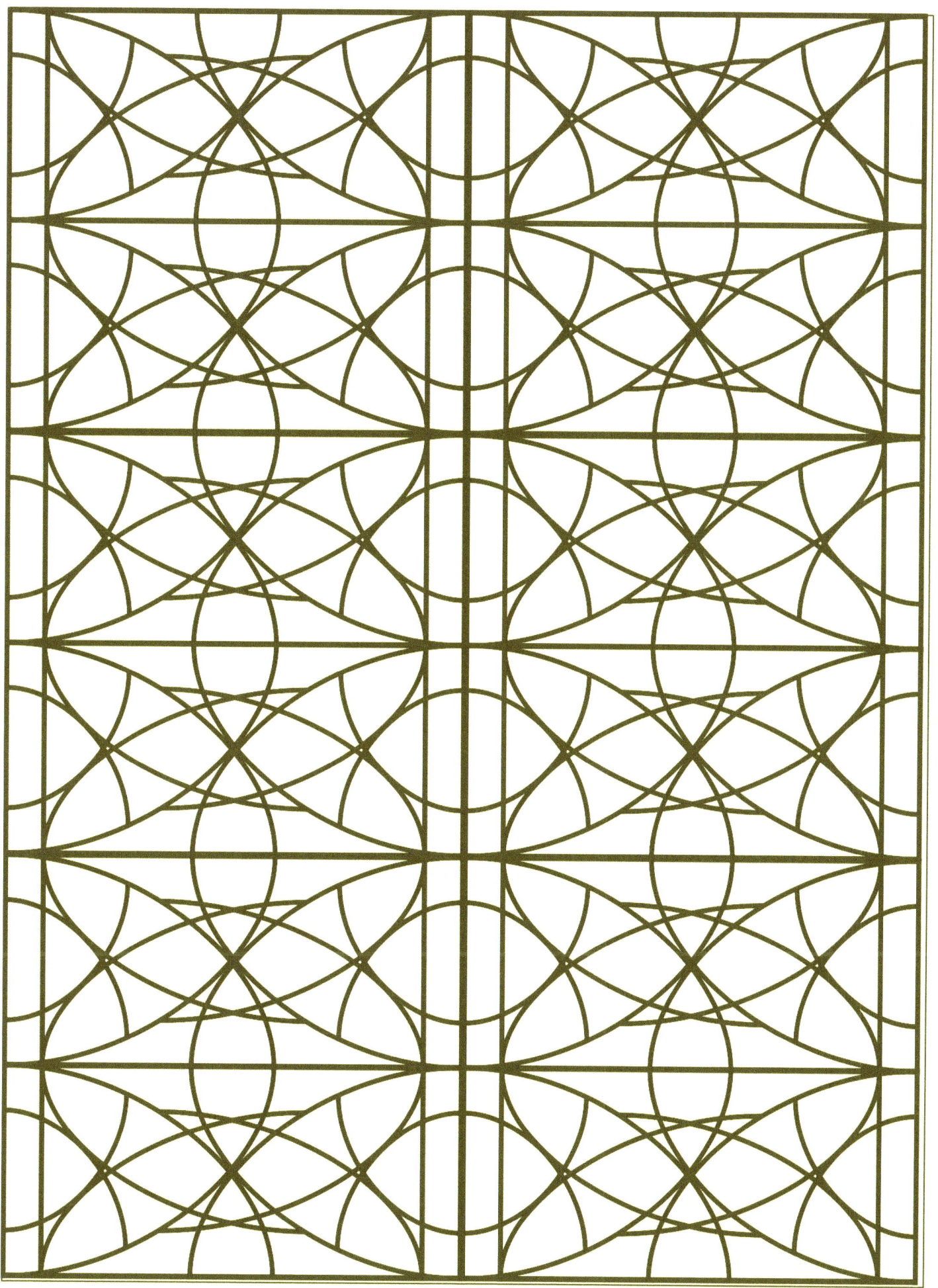

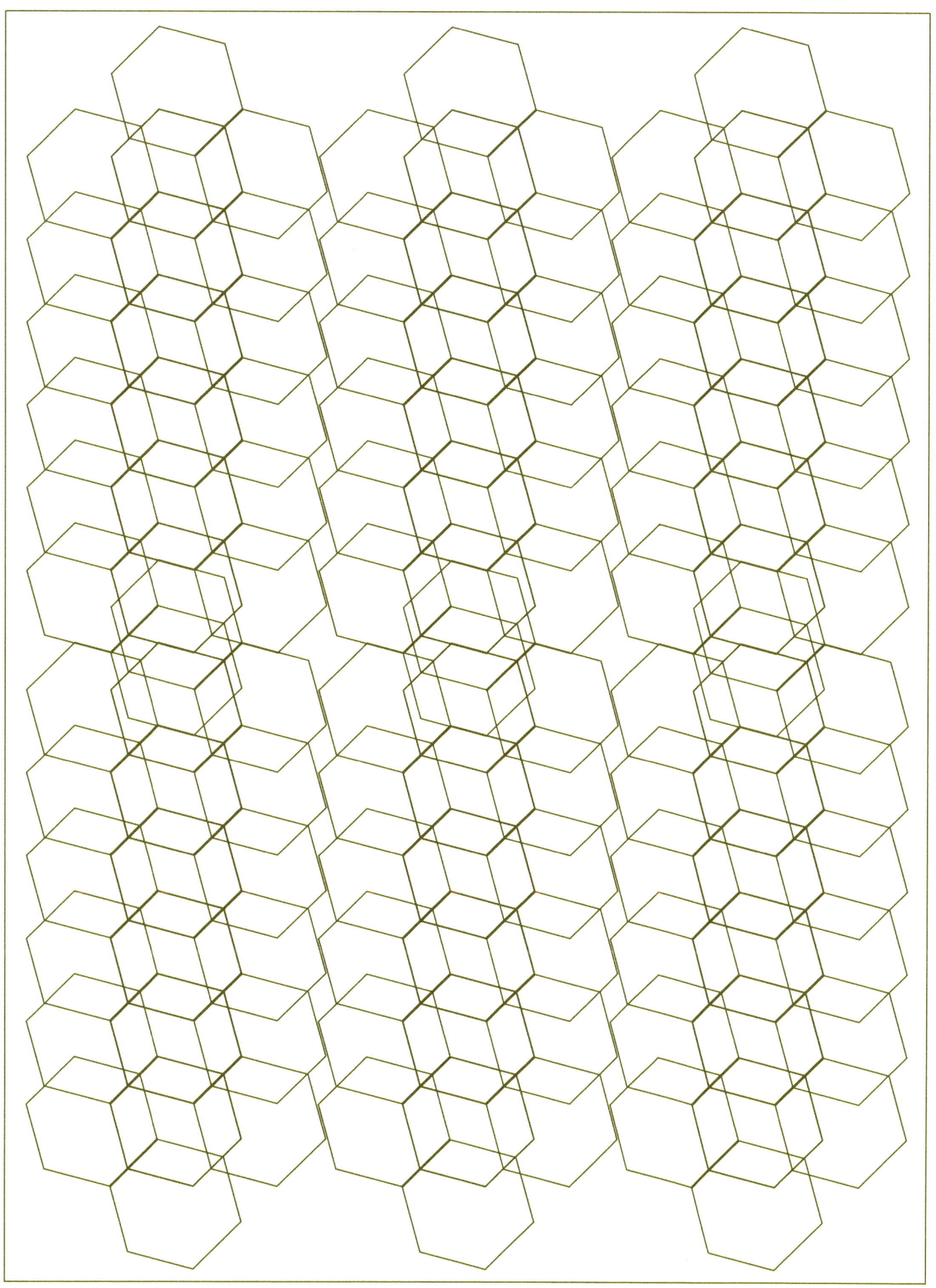

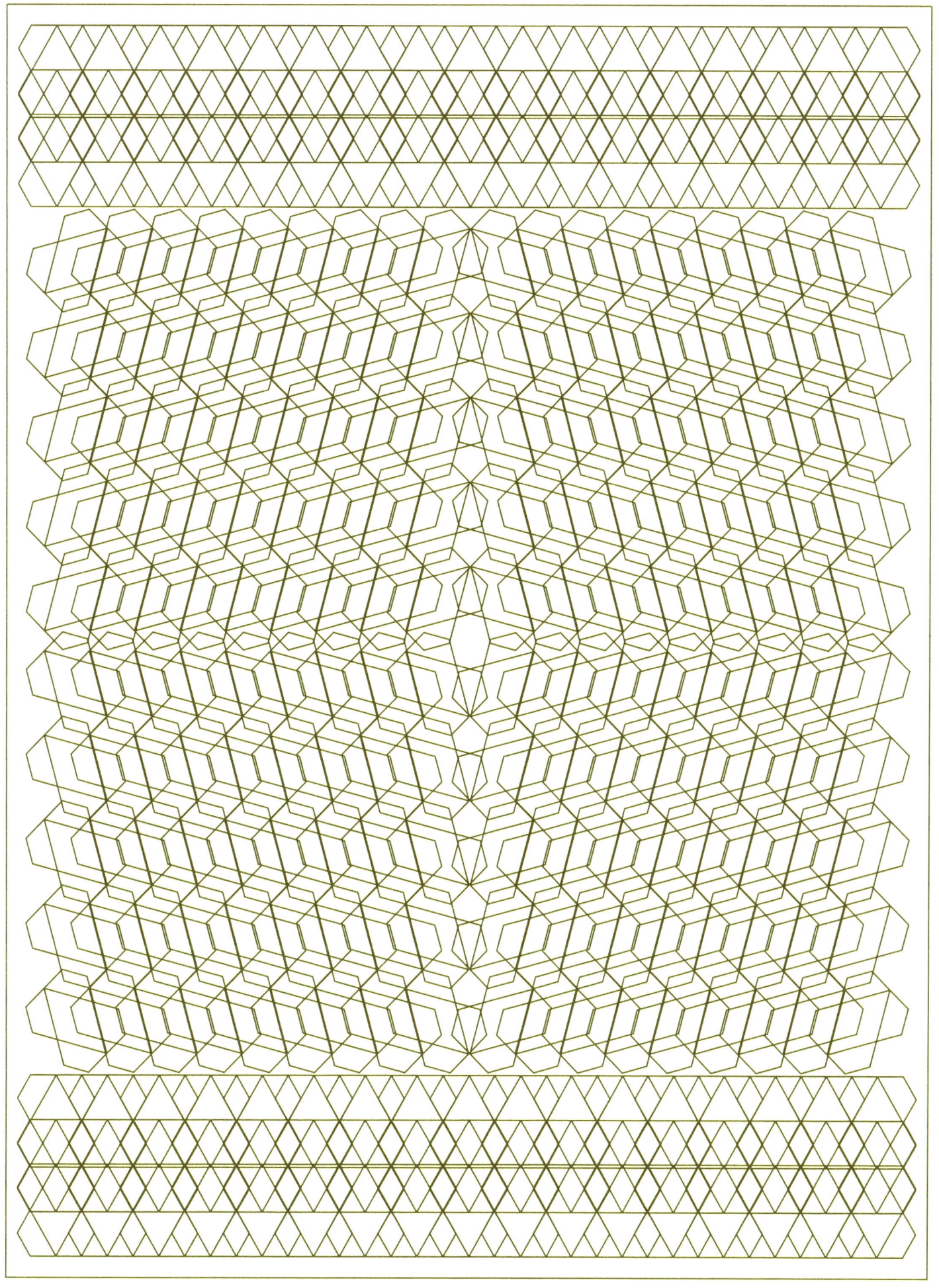

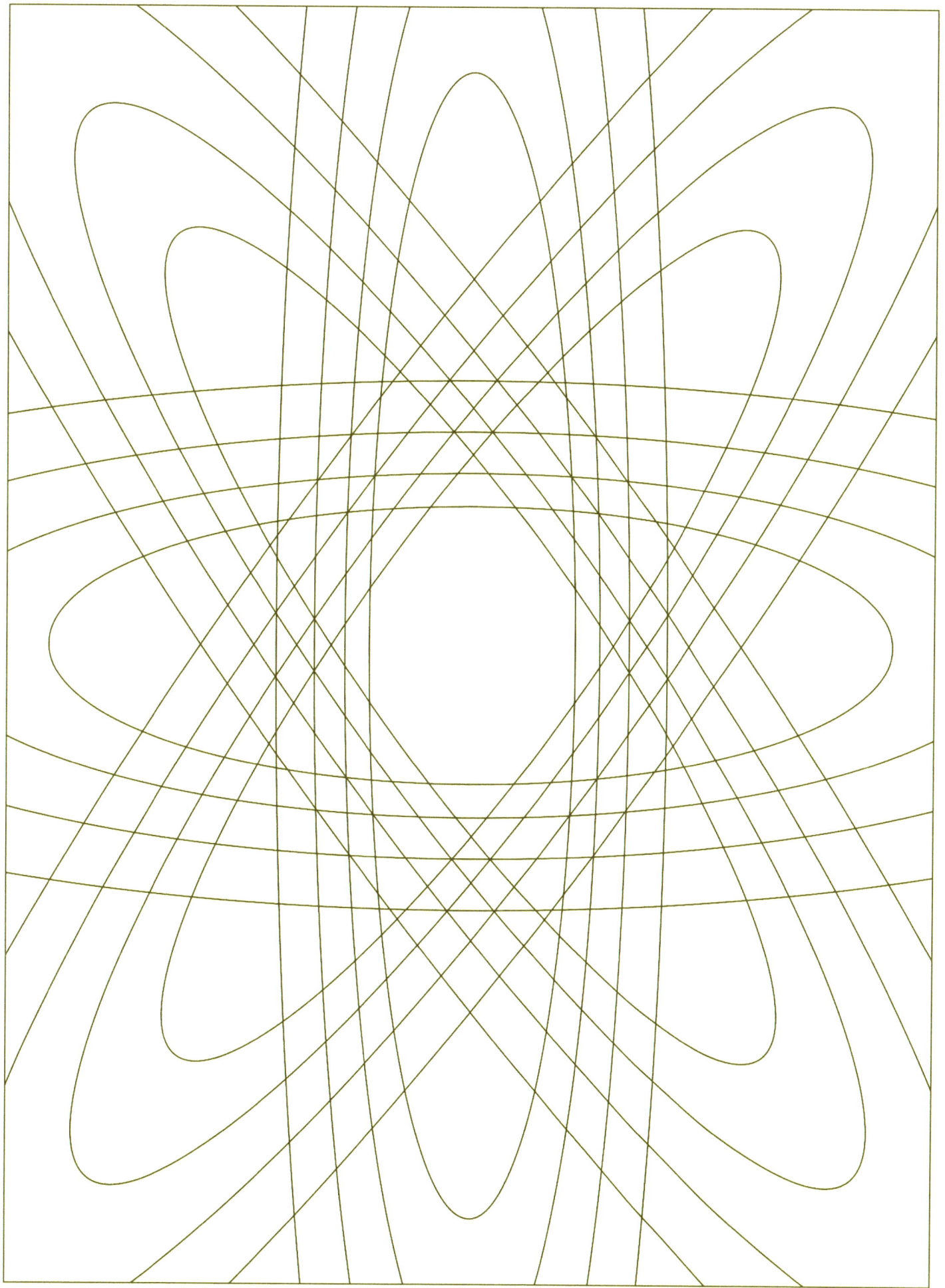

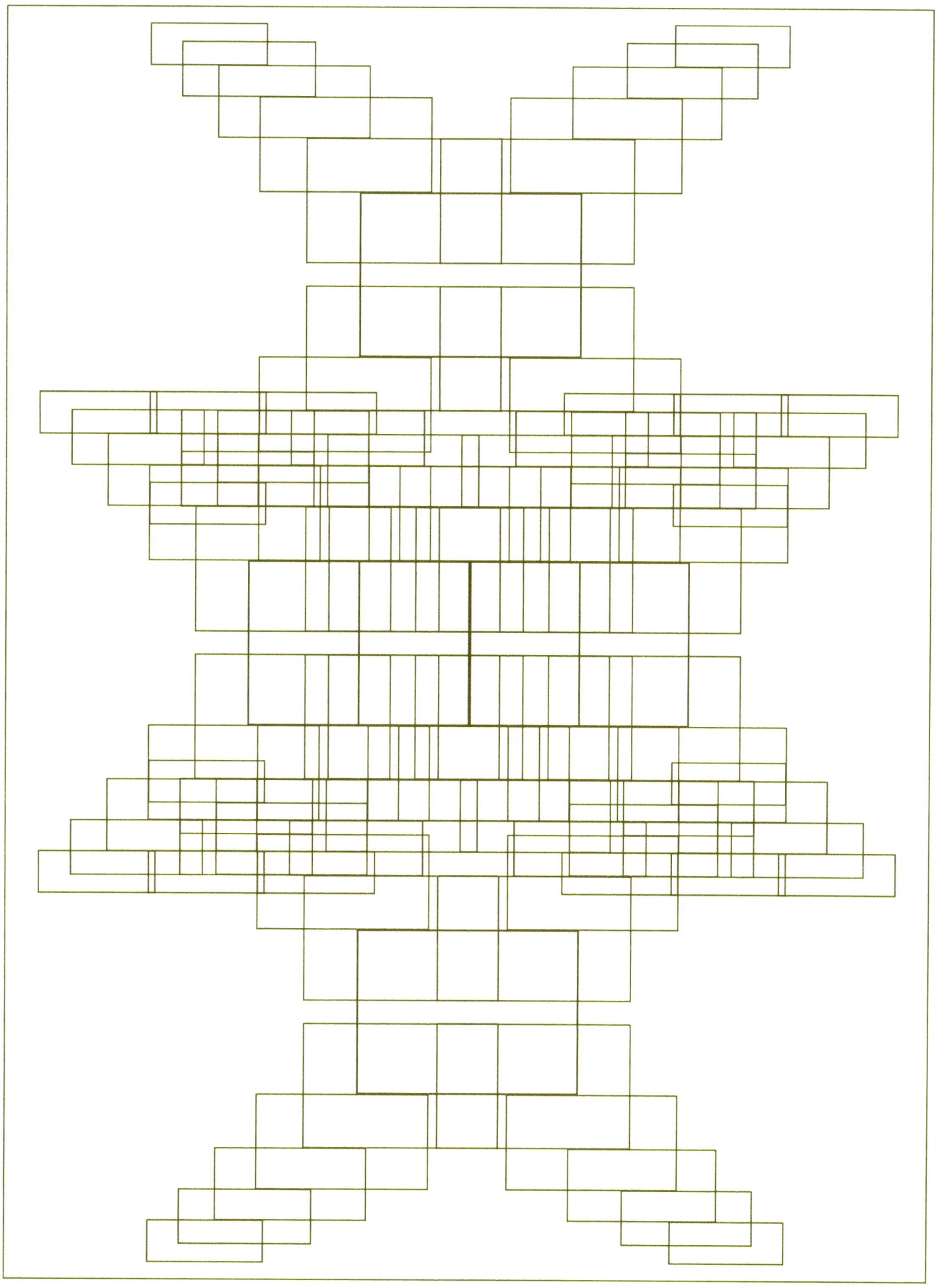

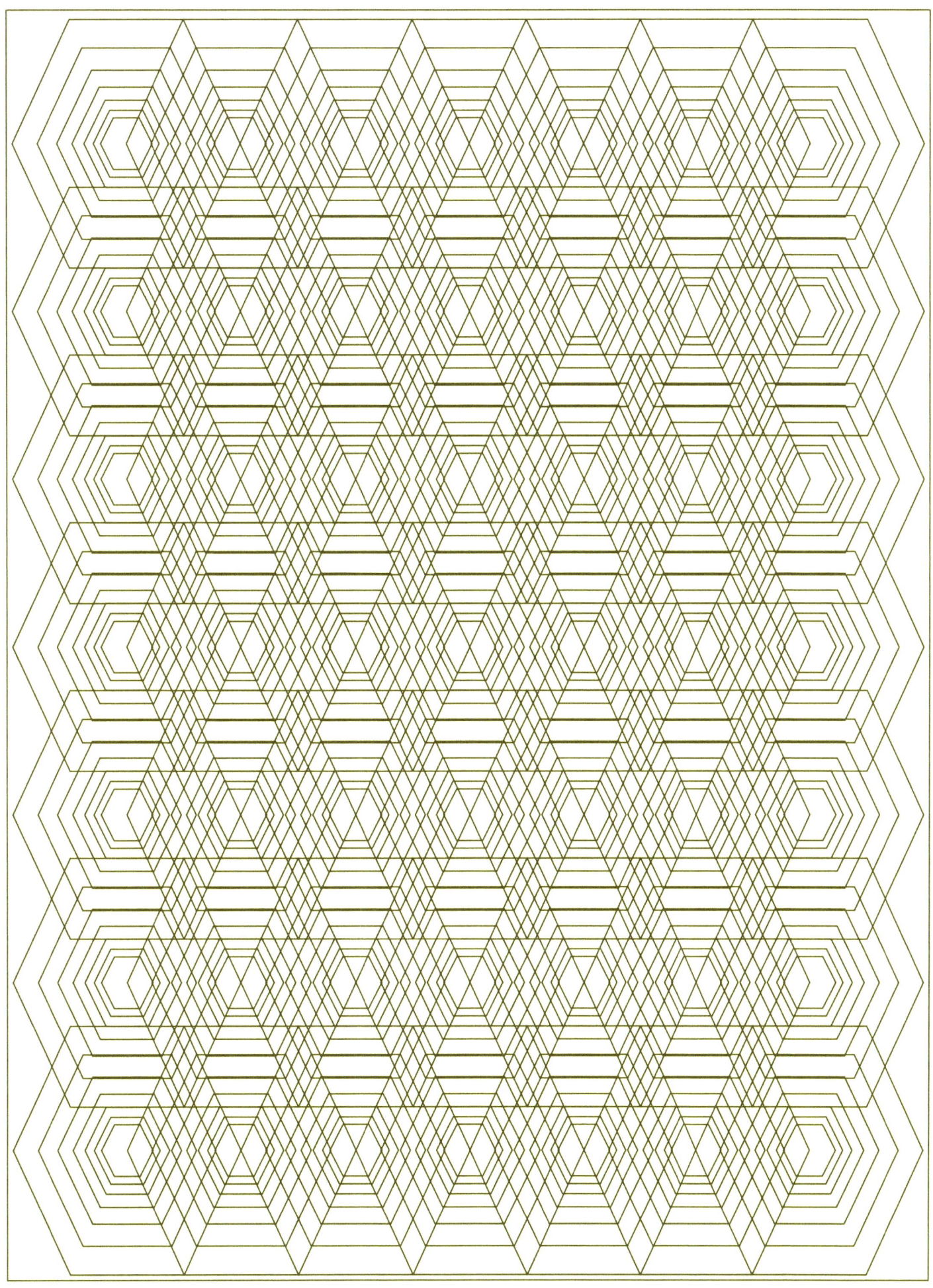

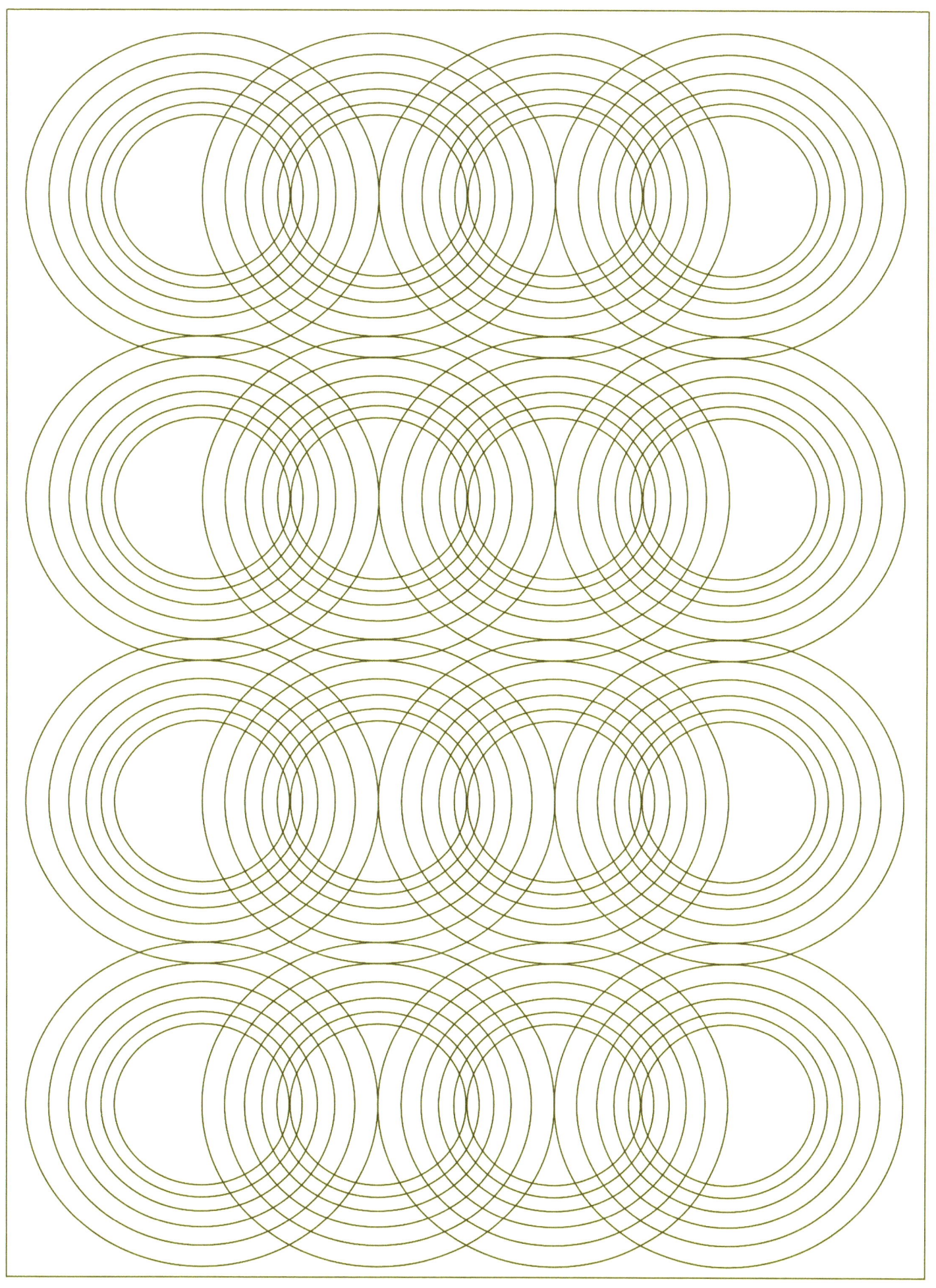

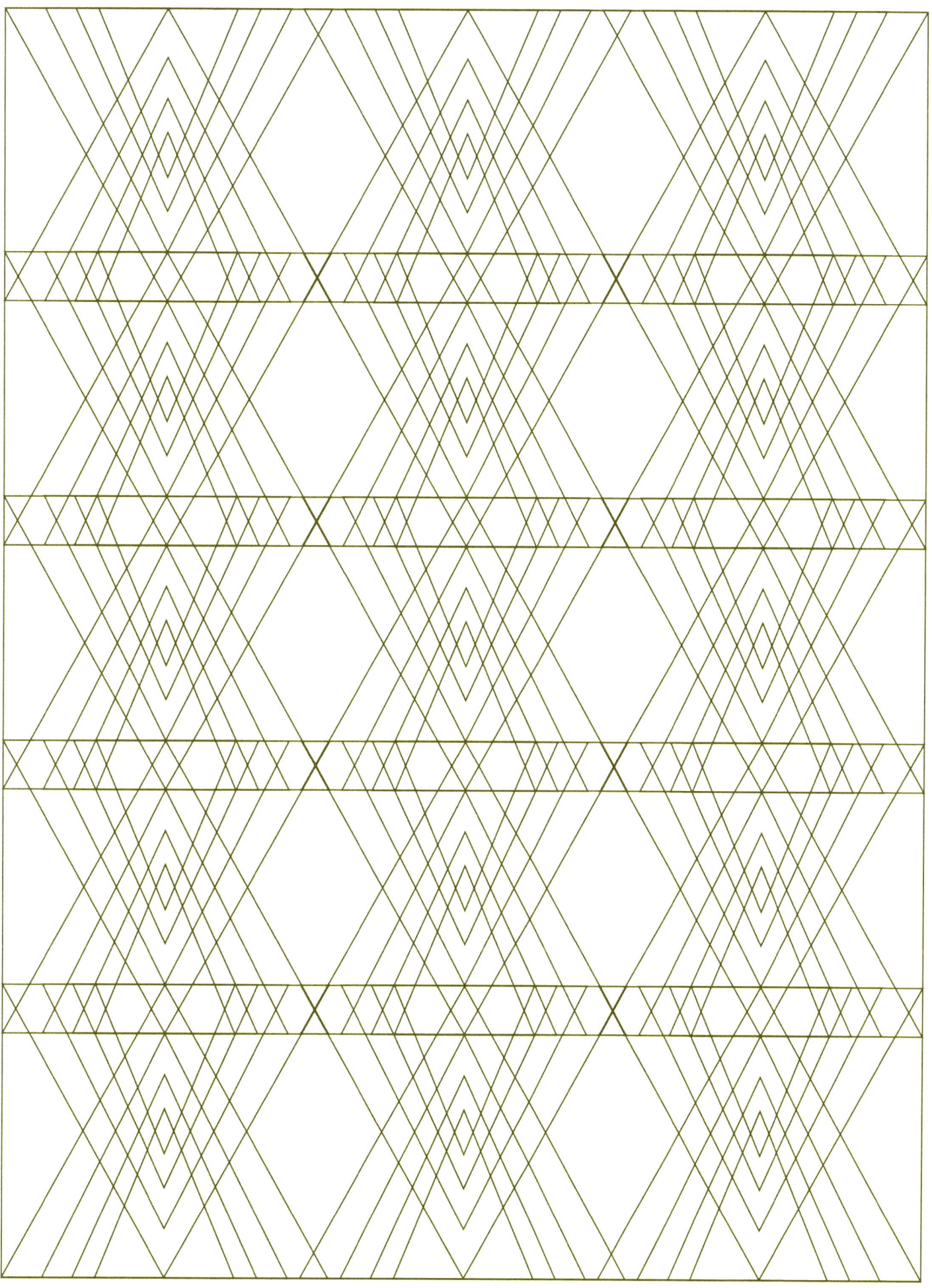

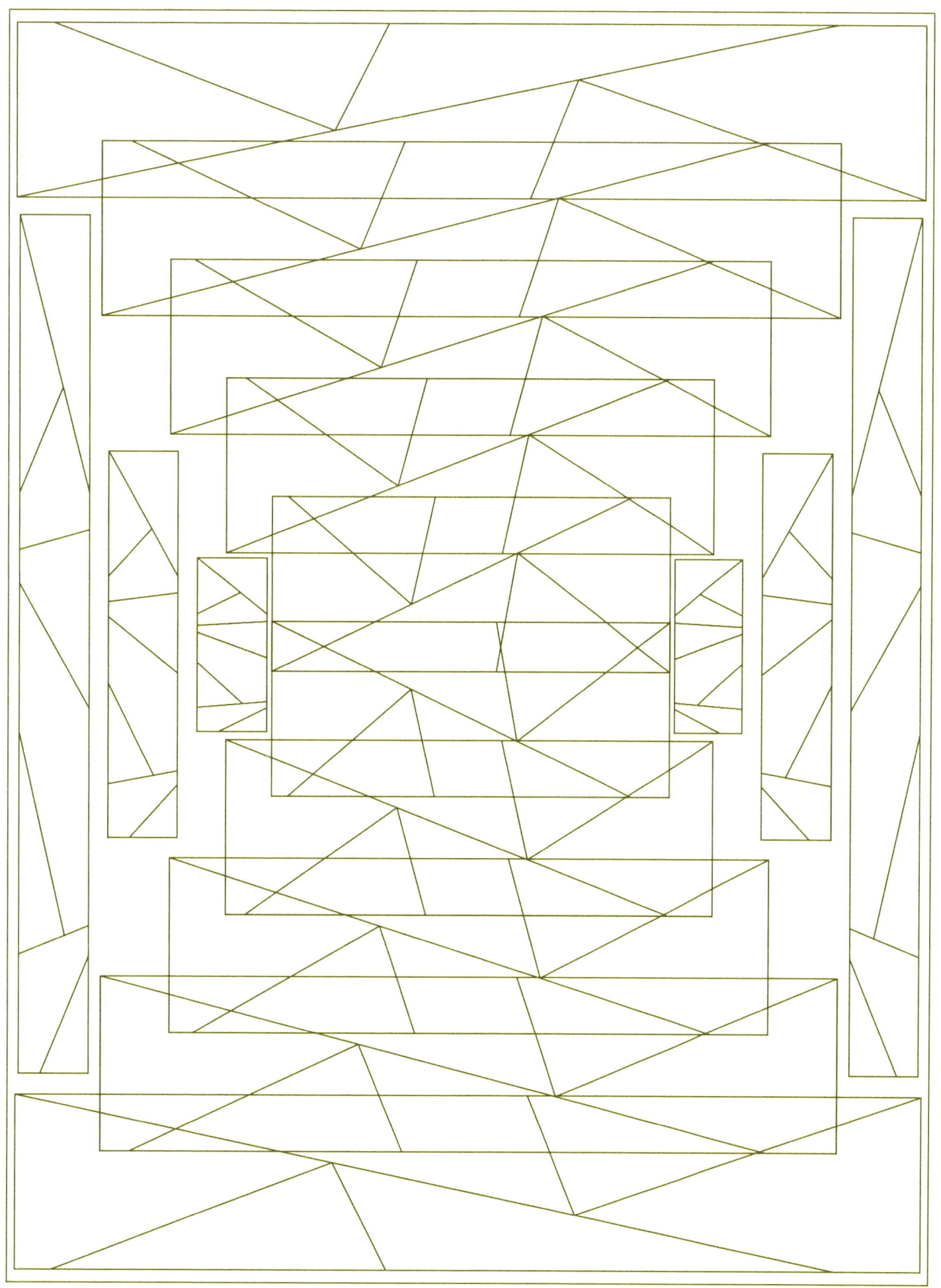

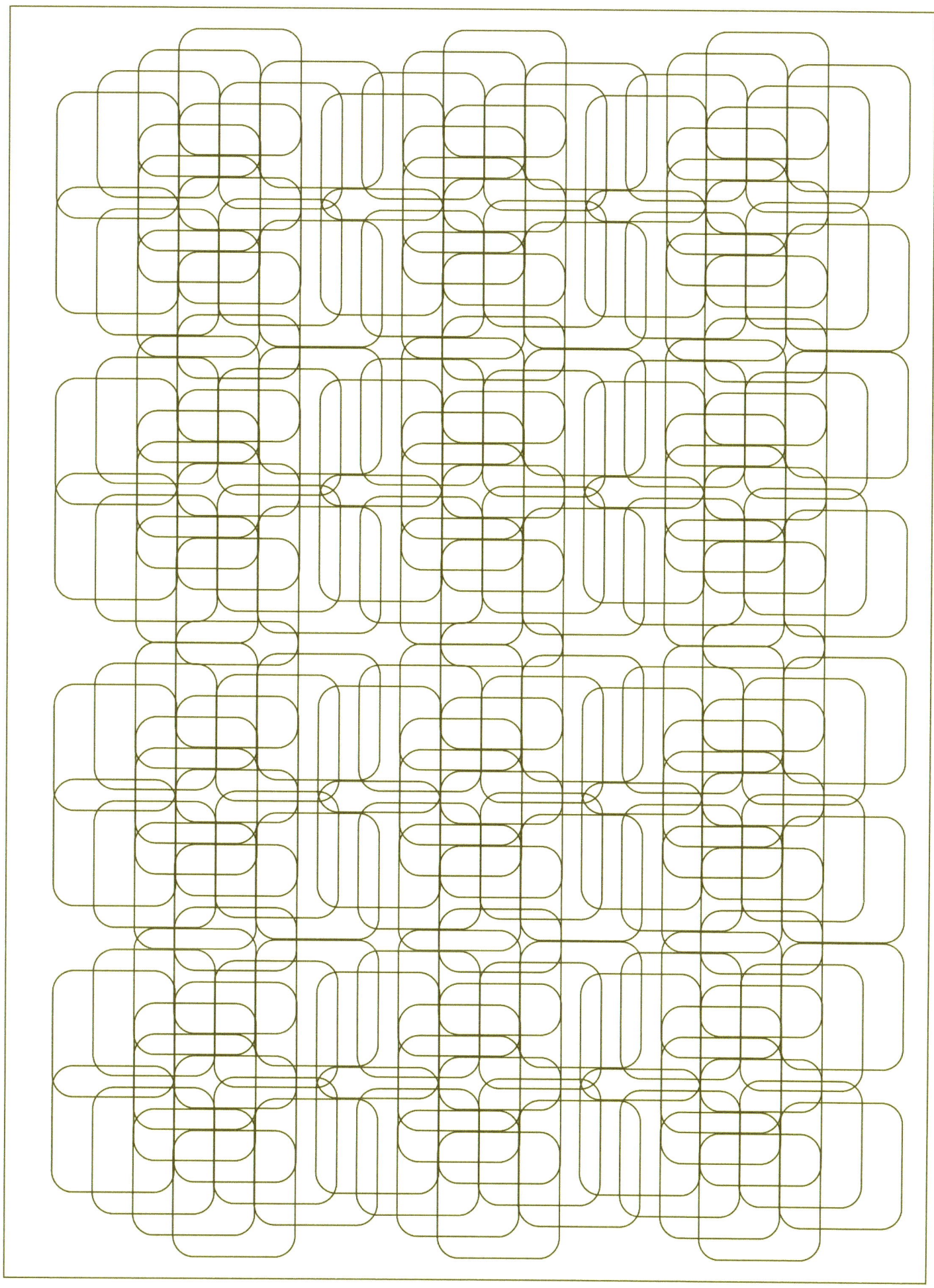

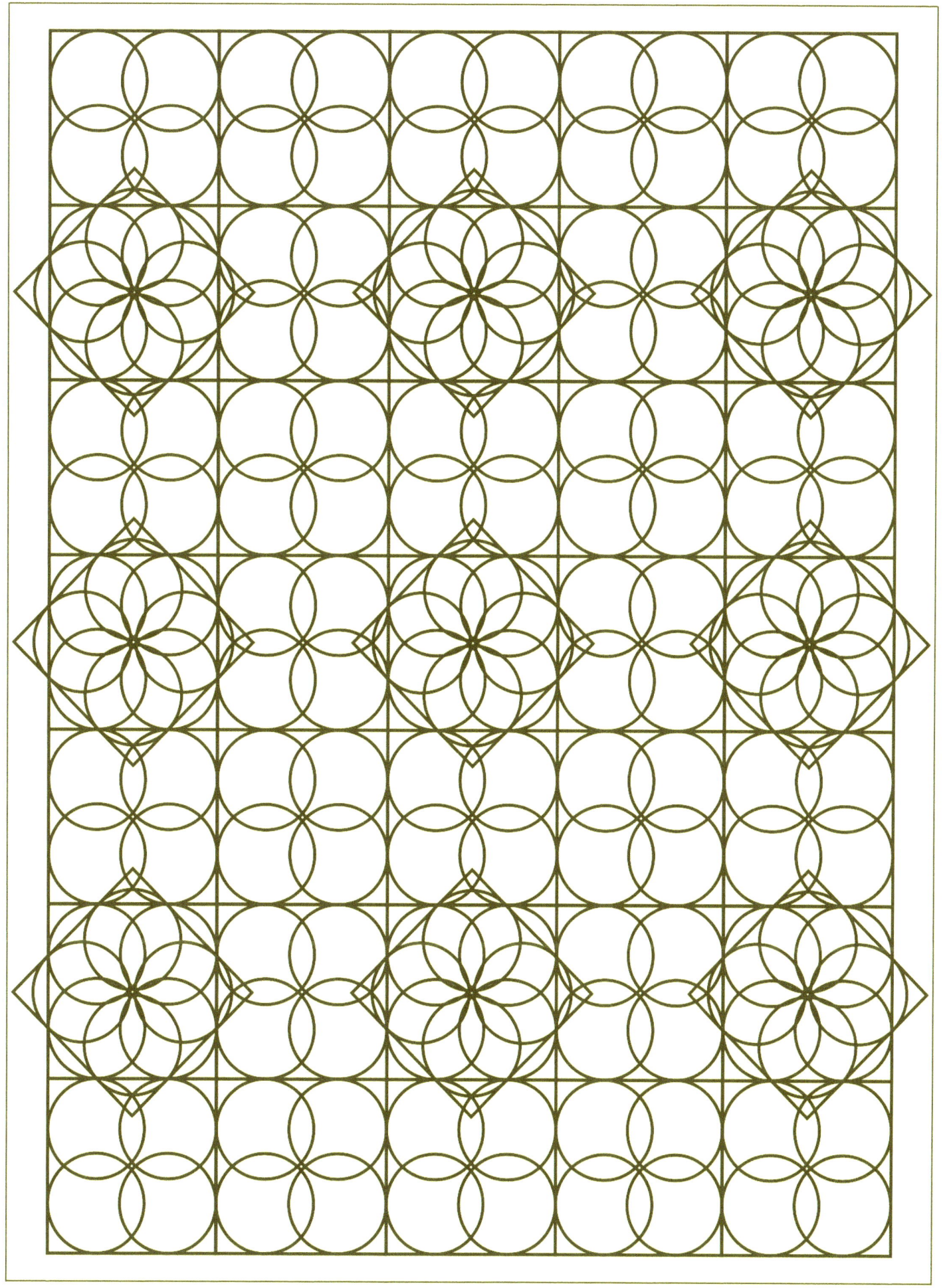

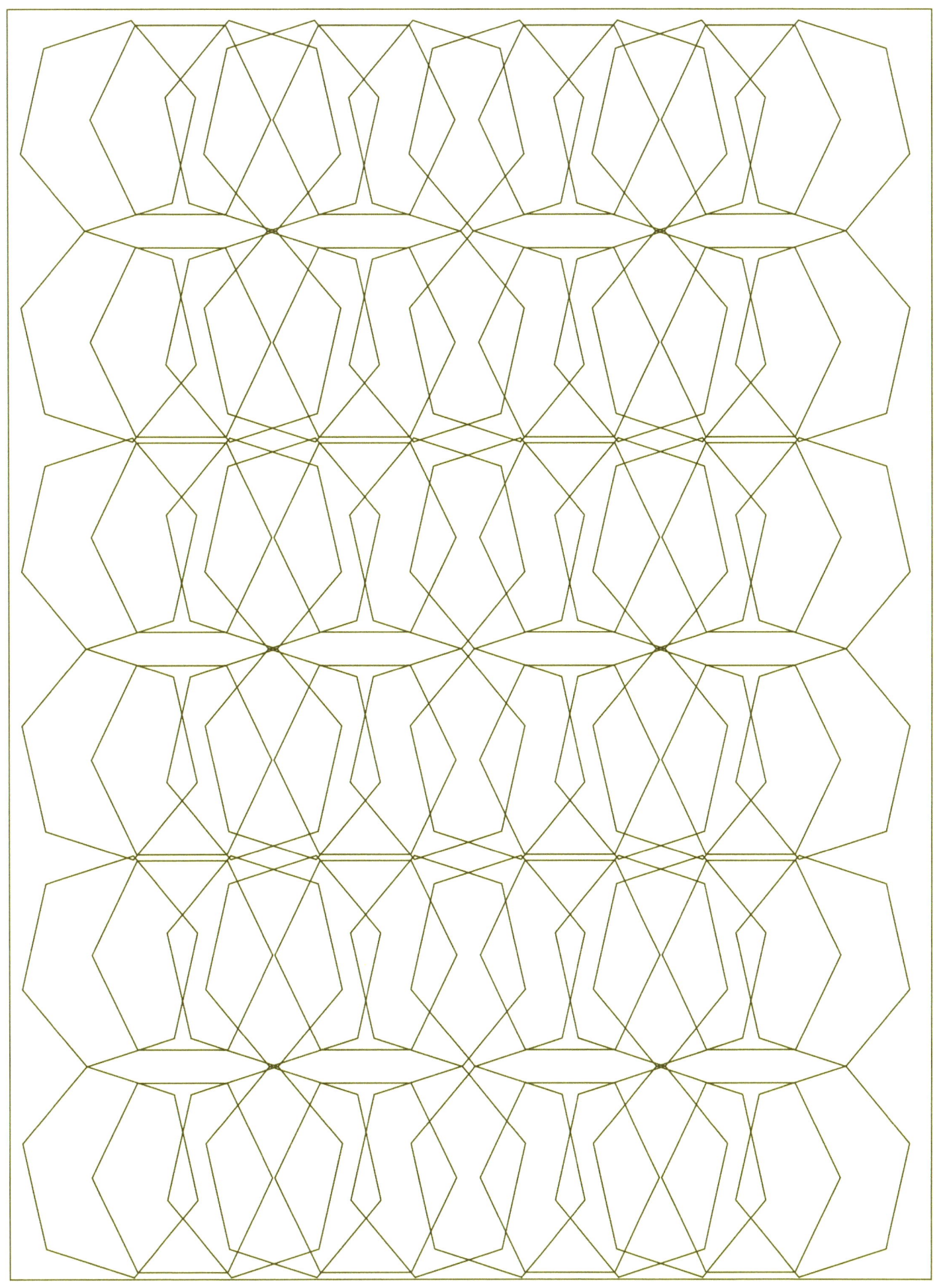

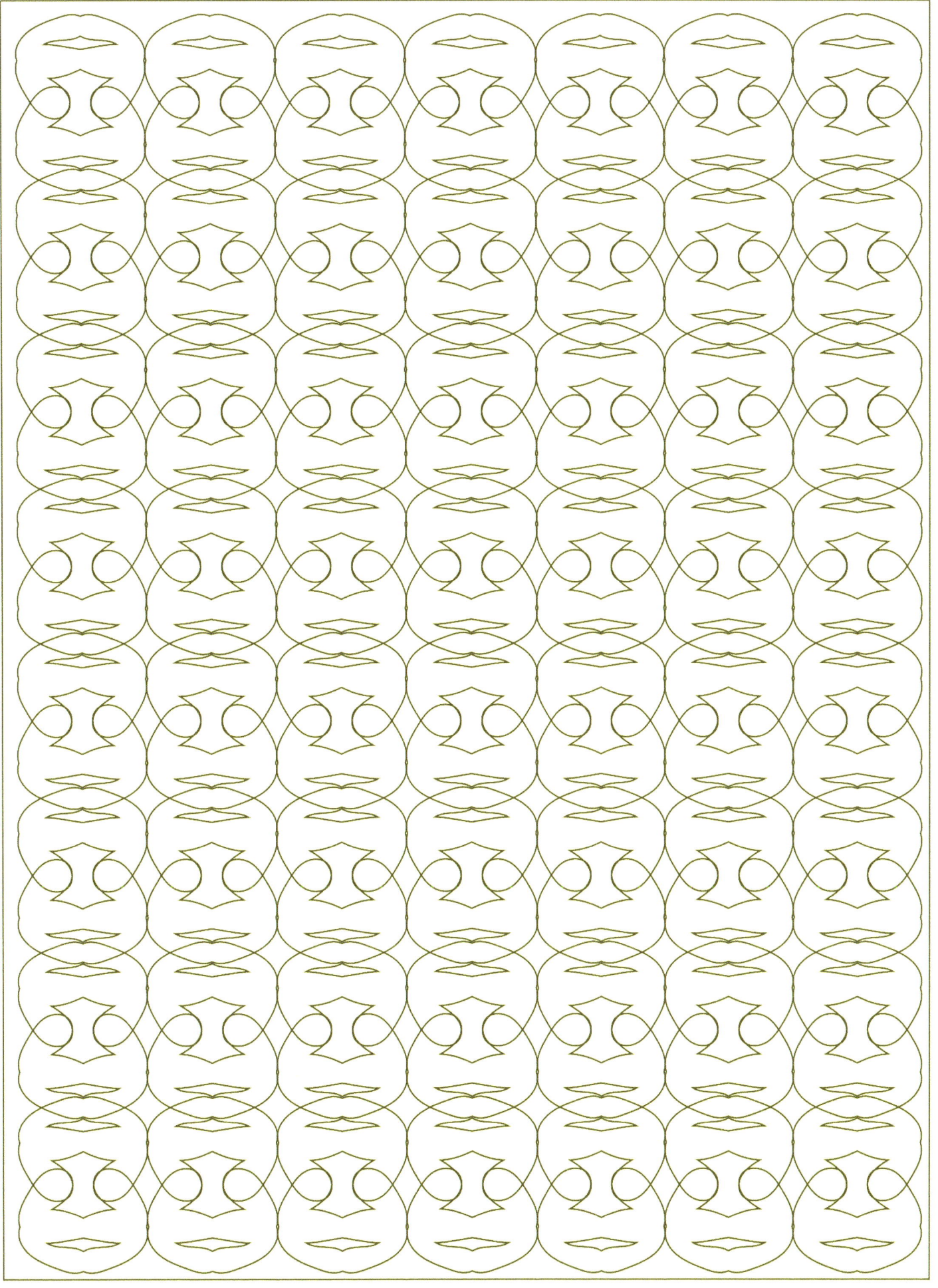

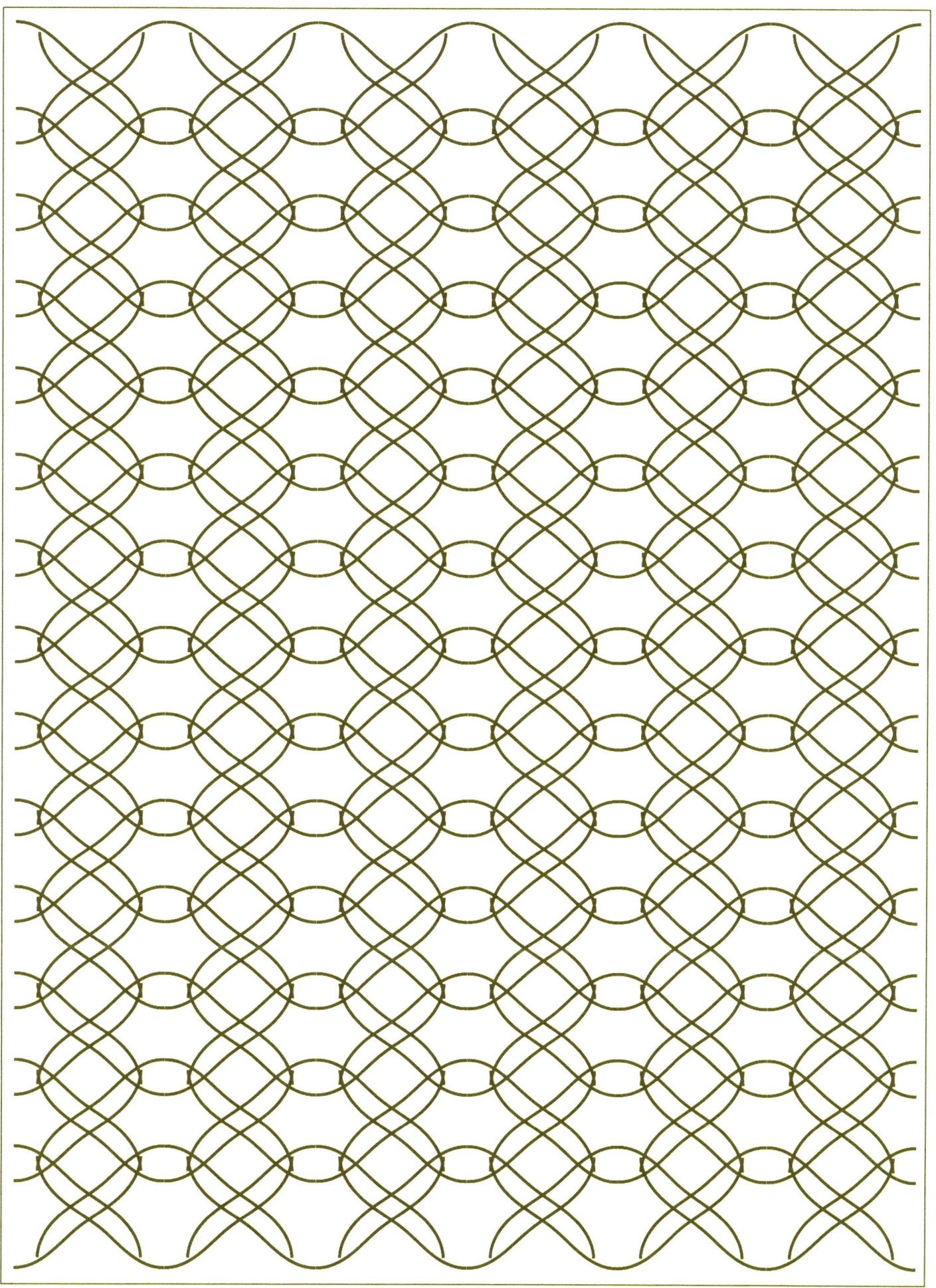

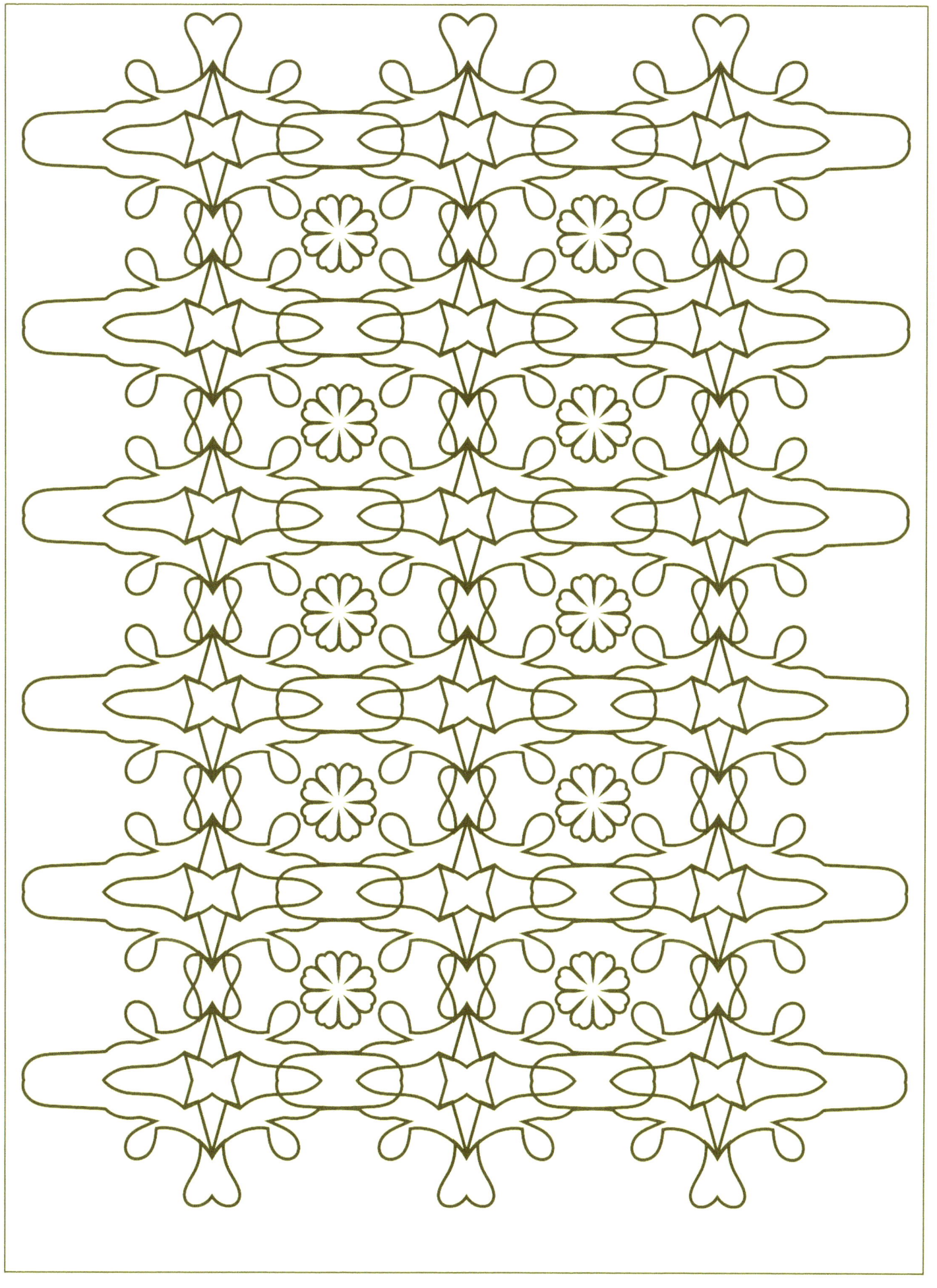

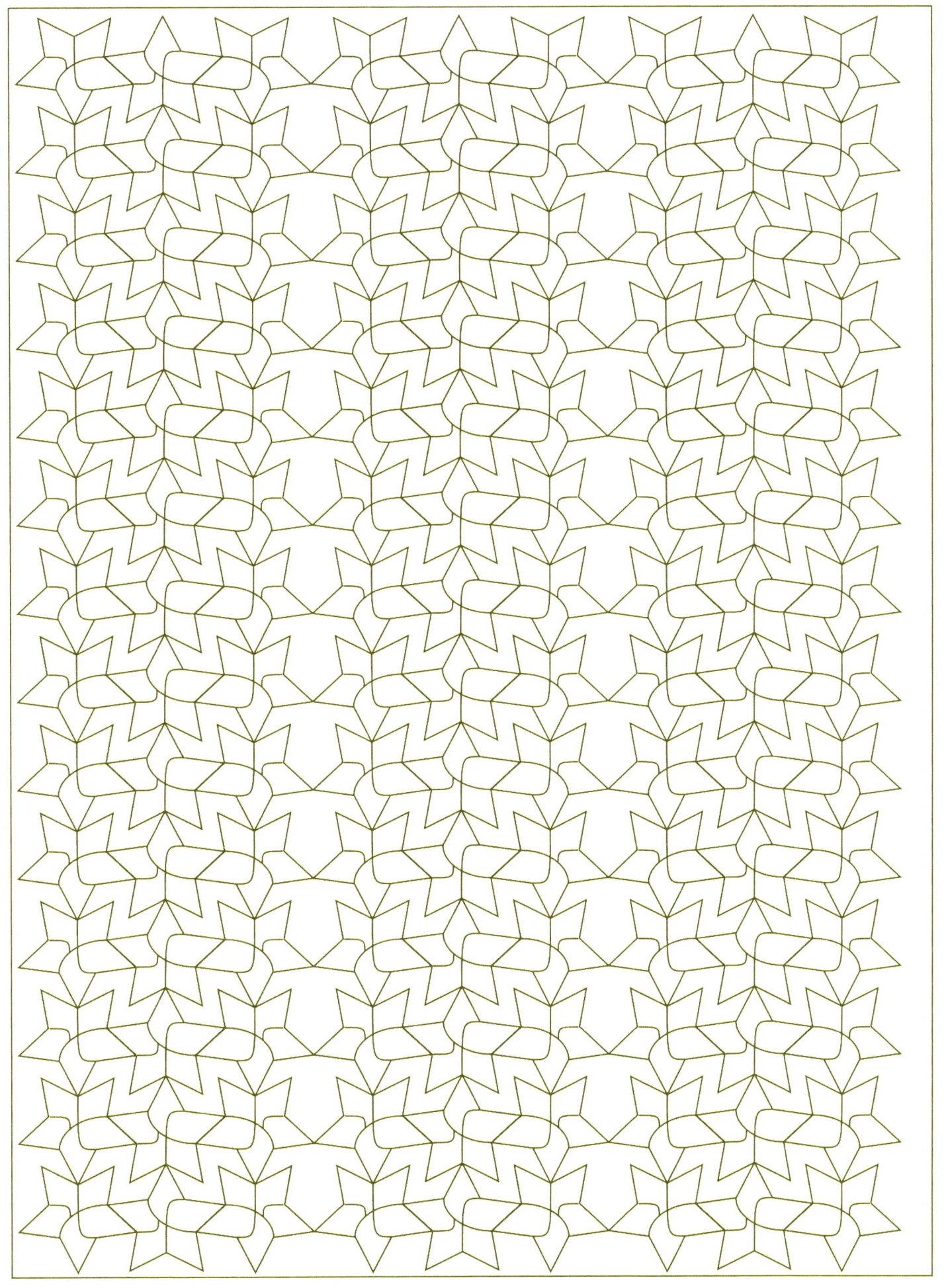

Thank you for purchasing Alien Design coloring books.

We hope you have enjoyed your foray into the slightly bizarre world of Alien Design.

Please stay tuned for upcoming releases.

© Alien Design™ 2016

www.ingramcontent.com/pod-product-compliance
Lightning Source LLC
Chambersburg PA
CBHW080545190526
45169CB00007B/2638